Poems for a Phantom Lover

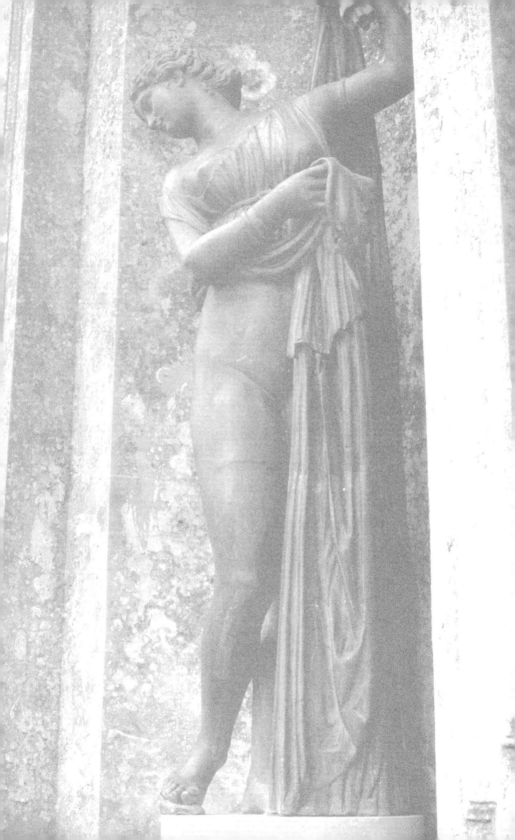

Poems for a
Phantom Lover

Jennifer Dickson

The Porcupine's Quill

Library and Archives Canada Cataloguing in Publication

Title: Poems for a phantom lover / Jennifer Dickson.
Names: Dickson, Jennifer, author.
Identifiers: Canadiana (print) 20230162185 | Canadiana (ebook) 20230162231
 | ISBN 9780889844681 (softcover) | ISBN 9780889844698 (PDF)
Classification: LCC PS8607.I3395 P64 2023 | DDC C811/.6—dc23

Published by The Porcupine's Quill, 68 Main Street, PO Box 160,
Erin, Ontario NOB 1T0. http://porcupinesquill.ca

Copyedited by Chandra Wohleber.
Represented in Canada by Canadian Manda.
Trade orders are available from University of Toronto Press.

We acknowledge the support of the Ontario Arts Council and the Canada
Council for the Arts for our publishing program. The financial support of
the Government of Canada is also gratefully acknowledged.

Canada Council Conseil des arts
for the Arts du Canada

Canadä

ONTARIO ARTS COUNCIL
CONSEIL DES ARTS DE L'ONTARIO
an Ontario government agency
un organisme du gouvernement de l'Ontario

Ontario
Ontario Media Development
Corporation

This book is dedicated
to my son, Bill Sweetman,
and his wife, Yvonne Bobrowski.

In memory of
Ronald Andrew Sweetman.

Contents

A Personal Journey

As a child in South Africa, I was hypnotized by a profusion of pink Fairy Roses tumbling over a fence in our yard. Then by my mother's Amaryllis in its vivid iridescence, a hypnotic note in a bleak environment.

In 1954, arriving in London as a student, I enrolled at Goldsmiths College School of Art, where my mother's cousin was vice-principal. England was still scarred from World War II. The City of London a flattened wasteland, the bomb sites now softened by an abundance of wildflowers. The air was toxic from the burning of coal, and fog sometimes brought the City to a standstill.

By 1957 I had saved up sufficient funds to embark on my own Grand Tour of Italy, well prepared by my cousin's art history lessons. By train and bus, I crossed the Alps and arrived in Venice. I was already transfixed by the Canalettos in English collections. Step by step, I compared the painted images with reality. As I travelled through the landscape, I recognized the background images of the 15th- and 16th-century Italian painters. I walked through Rome in the steps of Piranesi.

On my return to London, I devoured the collections in the Victoria and Albert Museum and started to loiter in the caverns of the British Museum. As I studied history, the past came alive and haunted me. I began to journey in time. The gardens came later. I had to leave England to find them.

7

παράδεισος, a Greek word of Persian origin, was used to describe an enclosure where wild animals and birds were kept for the royal hunt. Within these Paradeisos were also exotic fruits and flowers and ornamental trees. Inspired by the royal parks of Iran, the concept spread to Greece, then Rome, then to the estates of nobles in France, Germany, and England.

The English nobility educated their sons by sending them to France and Italy on a Grand Tour. The idea of the Paradise Garden was brought back to England in the late 17th and 18th centuries by individuals such as Lord Burlington, who transformed their landscapes with the assistance of European landscape designers. Subsequently, English designers like William Kent and Lancelot (Capability) Brown were widely employed by the nobility.

The Earthly Paradise

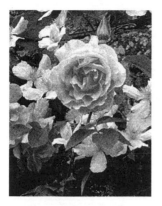

England, 1980–1982

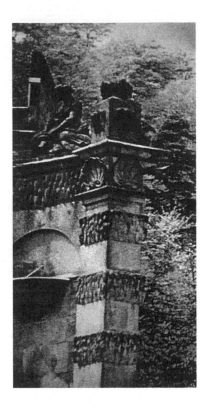

Underlying the symbolism of these gardens was a deep knowledge of the classical world and its symbols and deities. This knowledge was integrated into the landscape designs of the 18th century. Statues of Greek gods and goddesses, and reference to Greek legends, were part of an erudite garden. Accompanying the development of these landscapes was a burgeoning knowledge of hydraulics applied to the management of canals and fountains and a serious study of plants and trees. Specimens were brought by sea, gathered by plant collectors from Europe, Asia, and the Pacific. Combining these resources, the nobility were able to recreate in these gardens the images of the romantic classical landscapes seen in the paintings of Claude Lorrain, Poussin, and Salvator Rosa, which they brought back from their Grand Tours.

Two of the main landscapes created in this period are Chatsworth with the Cascade laid out in 1694 by Grillet (a pupil of Le Nôtre), surmounted by the Cascade House completed in 1711 by Thomas Archer. Castle Howard was designed as a heroic landscape by Vanbrugh. The Temple of the Four Winds was completed in 1728 and Hawksmoor's Mausoleum was begun in 1729.

Once, as a young girl I danced

near fountains.

Lions guarded my pagoda,

and I believed in the promise of the rose garden.

I wore scented damask in my orangerie,

And danced with statues.

Falling water, and sunlight:

pursued by Apollo, I turn into Daphne.

❀

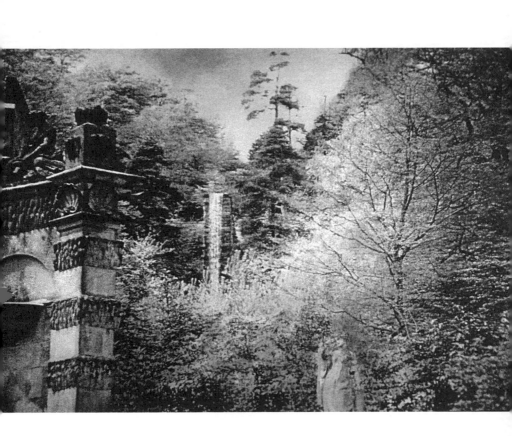

On the last day of spring:

As Gertrude Stein said to Alice B. Toklas:

'A rose is a rose is a rose.'

I am a cemetery,

I am a rose.

Roses bloom in cemeteries.

❊

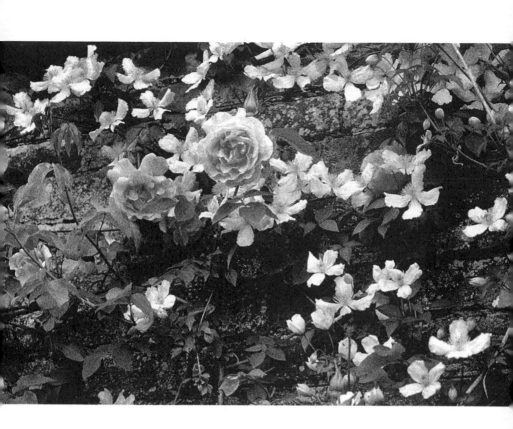

The Bride was bedecked,

but the garden enclosed,

and the Bride, abandoned.

A stone for the lost child;

a fortress for the Sun's acolyte.

❈

.

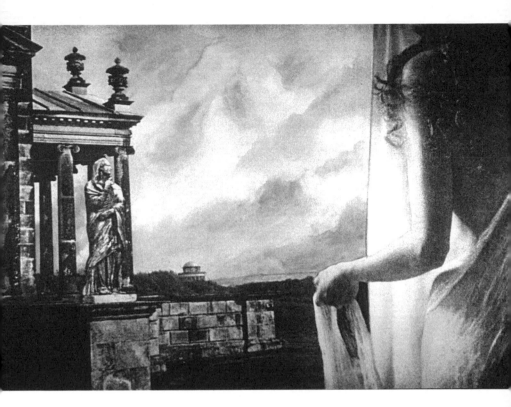

Enter the Sorceress.

❀

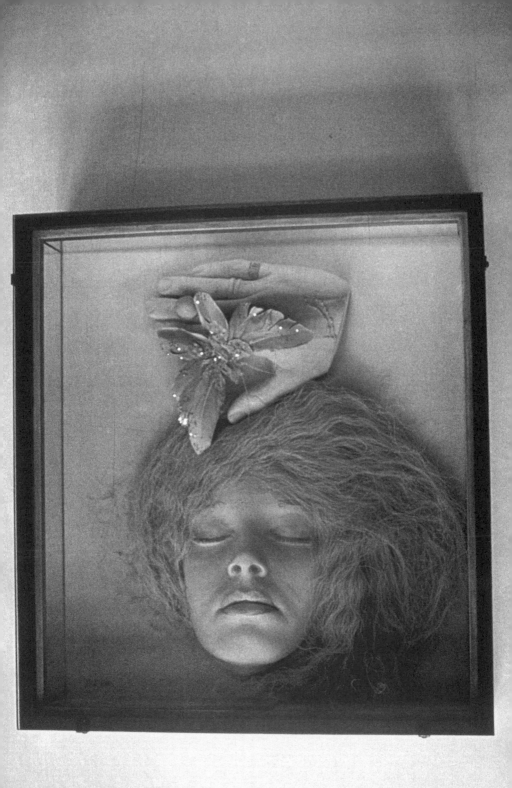

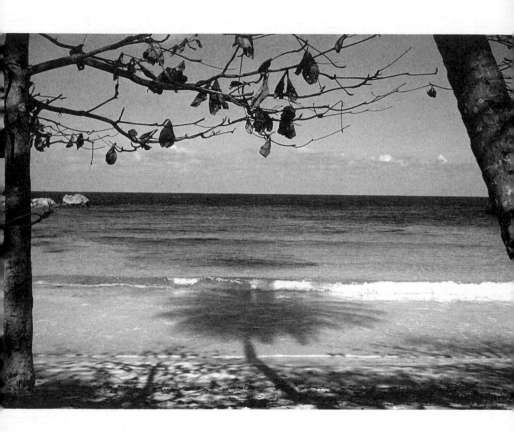

Out of Time

Jamaica, 1969–1970

We arrived in Jamaica on a banana boat late in 1969. 'We' consisted of my three-year-old son, my husband, myself, and our ginger cat, Perceval Lancelot. We were running away from the stress of my going back to work full-time when my son was ten days old. No such thing as parental leave existed in England at that time. We sold our house and left for warmer climes.

The moment we got off the boat in Kingston and drove through Trench Town, we realized we had made a mistake. We were aghast as we drove through the slums. People were living in shacks made from corrugated iron, plastic, cardboard, anything to improvise a shelter. We arrived at the house we had rented where the guard dog had been trained to bark at black people. It was an extreme transition.

It could only get better. After a while my husband's enthusiasm for jazz and reggae led to his meeting Jamaicans who were at the centre of a vibrant cultural scene: musicians, dancers, and writers. They were curious about us and welcomed us.

I found the landscape and wider environment fascinating. For the first time I had a real garden and the time to nurture it. The hedge was Bougainvillea, a vivid magenta tumbling over the fence. Hibiscus grew against a sunny wall and Birds of Paradise reminded me of South Africa.

England captured Jamaica from the Spanish in 1655. Prior to leaving, the Spanish released slaves working on the plantations. They fled to the interior mountains, Cockpit Country. From the mountains they conducted guerrilla warfare against the English military.

The John Crow Mountains are part of the Blue Mountains. They are the haunt of the Rastafarians who saw Haile Selassie as their Emperor. One day, walking along the South Coast, I saw a long sentence phrased in stone on the beach at the edge of the waves. It said: God is a Rasta Man. The Rastas had come down from the hills.

Further along the South Coast one can see evidence of Jamaica's volcanic past. The tide is stronger here and the rock is split into jagged shapes which would slash your feet. Occasionally you see delicate succulents growing between the shards of stone.

On the North Coast is a neglected botanic garden at the edge of a river. Here the tree orchids flourish in abundance while the Anolis lizard puffs his throat out like a fan.

In 1969 Trench Town burst into riots. The army was brought in to restore order. The university campus at Mona was surrounded by tanks and soldiers. My four-year-old son said, 'When I grow up, I don't want to go to university. I don't like the tanks.' He went back to playing on his tricycle with his friend. They had strewn their stuffed toy animals on the driveway and were riding over them. 'What are you doing?' I asked. 'We are playing squashed dogs,' he said.

This is my sacred space:

a place for foot-slashing

where the tide is sucked out,

leaving old men's rotten teeth,

and random gods

with no place to hide.

This is my stone,

my jagged cliff.

Stone my reality,

light hard as stone:

my altar, sacrificial block.

Villon was not the only one

to approach the sanctuary

and find the bird had flown.

❉

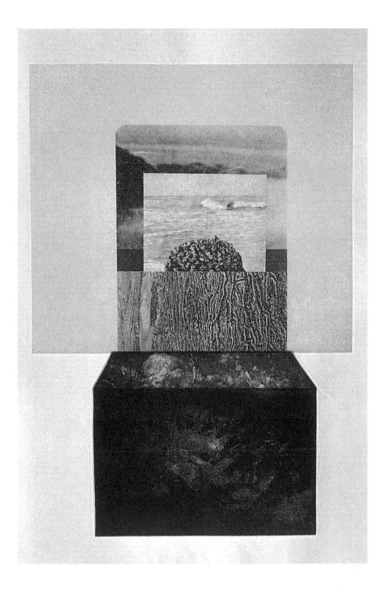

Goats bleat,

feet on porous rock, sharp,

and the bruised smell of leaves.

Most of this day

is my remembrance

of your remembrance

in me.

Search for me within your silence.

Love me, within you.

I will bid you to a feast,

and refuse you all but my love.

❈

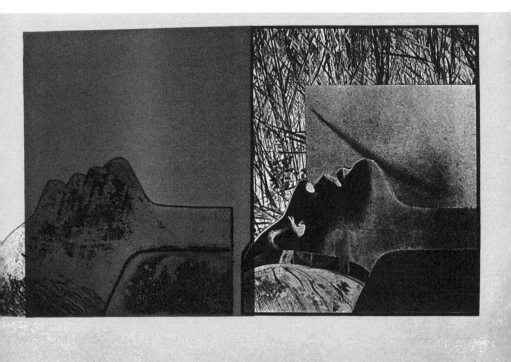

Second Time Around

It's a question of finding little boxes

in which to store the unused pieces.

Voices don't change, but hearts tire.

A silver-handled message for the panther:

my hunter's heart can sniff out the blood

beneath the fragrance.

This island nurtures betrayal.

You say you work with time:

smash it for me.

❖

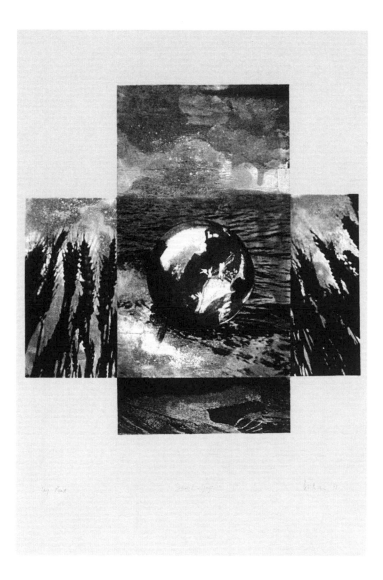

29

And you will take a plane,

and I will take a plane,

and the sky will devour us both.

❧

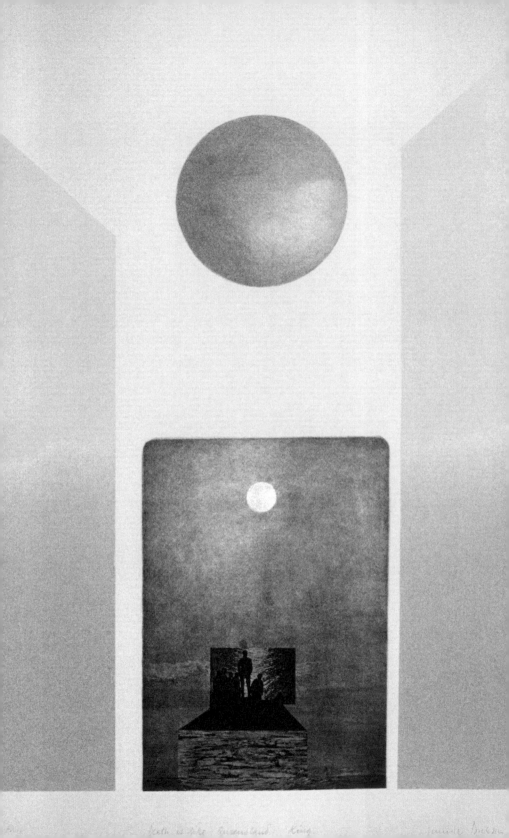

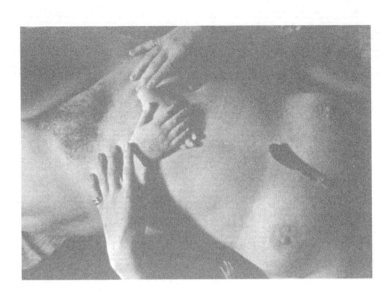

The Secret Garden

Canada, 1976–1977

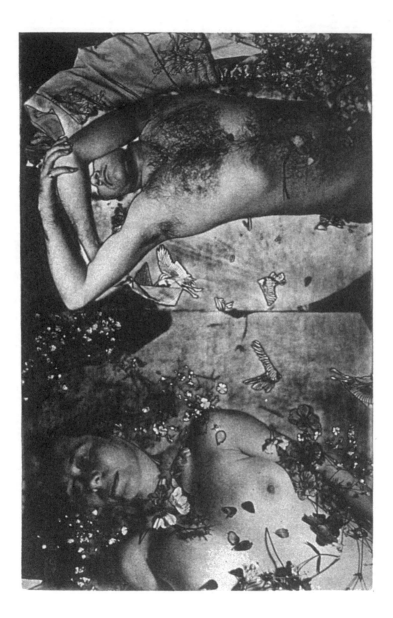

Before leaving Jamaica for Canada, I had completed the drawings for a series of etchings based on the biblical Song of Songs. The imagery in this suite was a fusion of female nudes linked to the tropical plants I had been inspired by in Jamaica. These included the climber, White Beaumontia and the Blue Passionflower.

Following our arrival in Montreal, I had access to the printmaking facilities of the Saidye Bronfman Centre. It was here I produced the etchings for the Song of Songs portfolio.

On moving to Ottawa in 1976 I set up my own studio. I embarked on a major project: *The Secret Garden* for the National Film Board's Still Photography Division under the leadership of Lorraine Monk. (The concept was linked to the celebration of National Women's Day.)

Although I had been experimenting with the application of photography to etching since 1966, it was applied directly in the realization of *The Secret Garden*. The narrative sequence included both the male and female nude and dealt with conception and birth. I collaborated on this project with the photographer Ray Van Dusen.

The Night-Hawk

No-one else will know you

quite the same,

will tame the gentle lion

who sometimes trembles in my arms.

And when the night-hawk

soars above me in the spring

will know the glancing quiver of his wings.

For I was touched, and burned

by his embrace.

❈

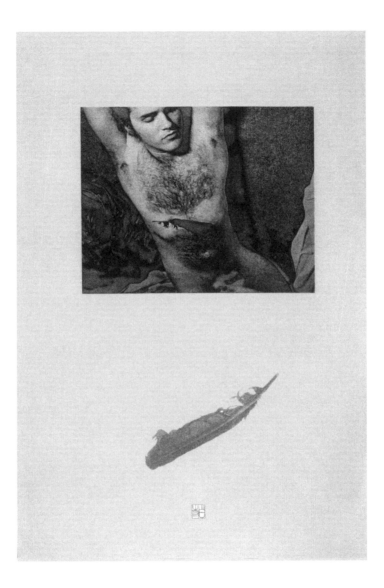

On April 25, 1970, to my great surprise, I was elected an Associate of the Royal Academy of Arts in London.

The portfolio of *The Secret Garden* was presented to the Royal Academy as my Diploma work.

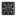

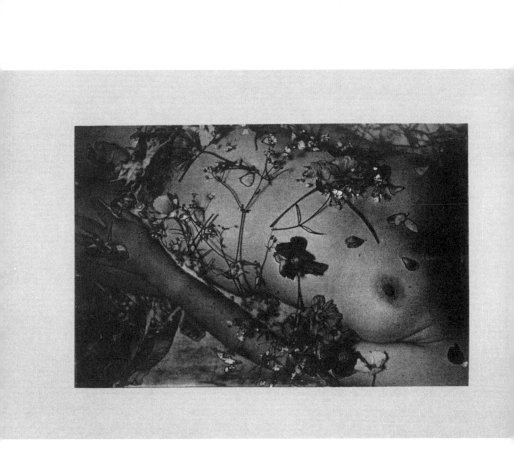

The Hospital for Wounded Angels

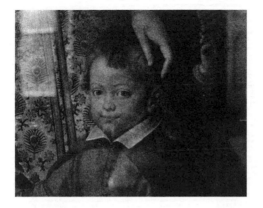

Italy, 1980–1990

Being elected a Royal Academician altered my life. I had to
fly from Canada to London at least once a year to fulfil my
obligations as a member. I planned these yearly visits
systematically in order to combine them with visits to
gardens in Italy, France, the U.K., Spain, Portugal, and
Morocco.

I began to present lectures on the gardens I had visited and
photographed. They also became the source of the paintings
and prints I worked on in my studio in Ottawa. In 1981 my
first series of garden lectures was held at the National
Archives of Canada, using material I had photographed in
Italy in 1980. This lecture series featured the Villa of Catullus
at Sirmione; my initial visit to Isola Bella on Lake Maggiore;
the Giardini dei Giusti, Verona; Villa Barbaro, Veneto, and
Villa Pisani at Stra.

My first series of prints on English gardens was published in
1984 as *The Gardens of Paradise*. The portfolio included
Stourhead, Newstead Abbey, Rousham, and Bowood.

In 1987, at the suggestion of Jane Urquhart, I collaborated
with Tim and Elke Inkster of the Porcupine's Quill. A book of
poems and photographs titled *The Hospital for Wounded
Angels* resulted. Some of these poems and images are
included in this book.

The city is full of old women

dressed in black,

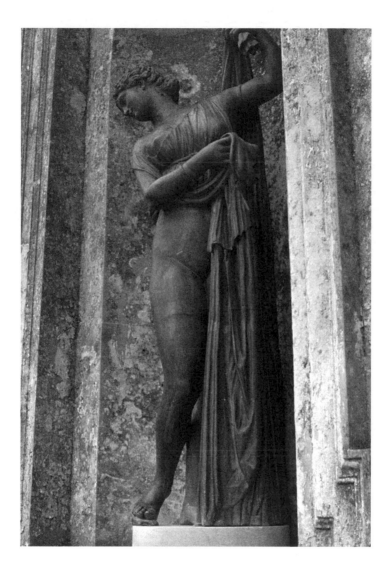

and young men I am forbidden

to embrace.

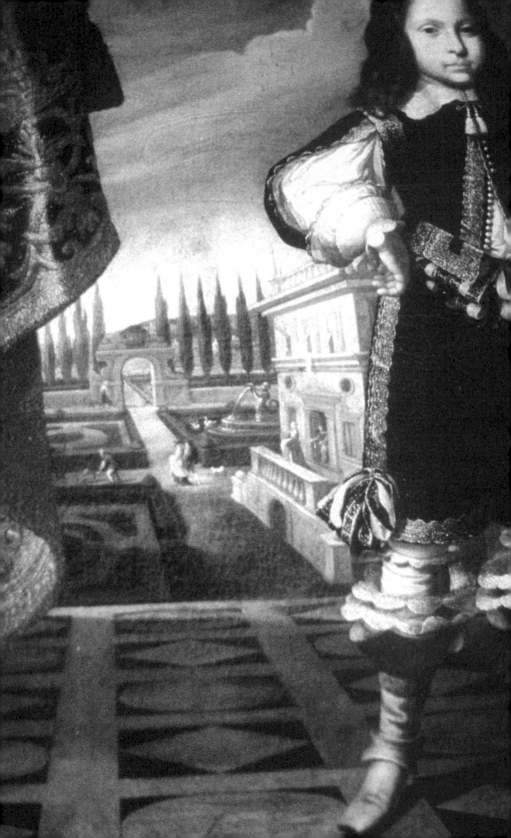

Underneath: darkness.

Lost in the mossy labyrinth, fern dank.

Memories fragment, wind borne

blue / sun. The mask of the puppet,

the tinkle of crystal.

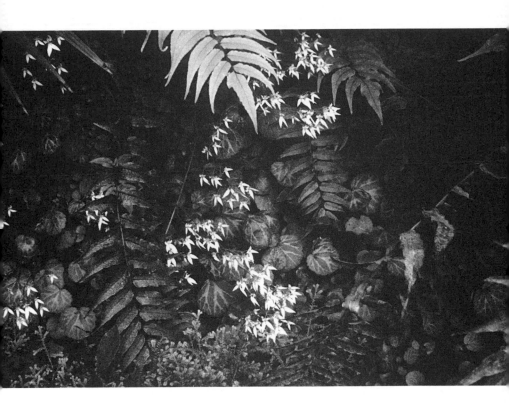

Laughter in empty corridors:

the last Borromeo princess.

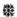

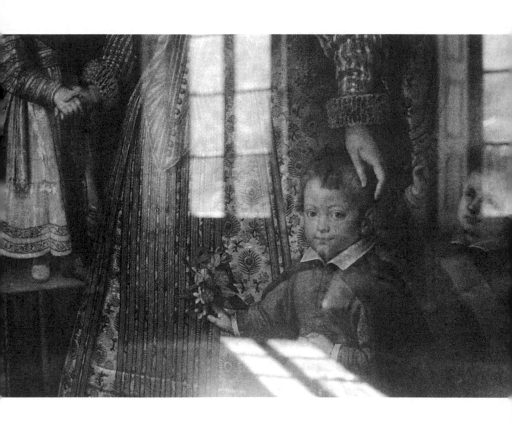

This Sunday morning sky so blue

(cloud formation courtesy of Canaletto)

Albinoni's Adagio on the organ,

note by note re-connecting the gentle kisses

which awoke

the slumbering lioness in my thighs.

❈

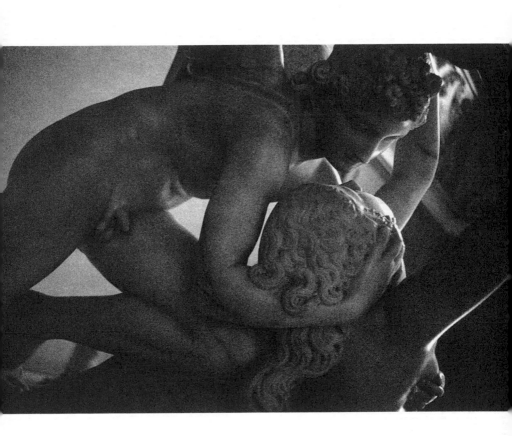

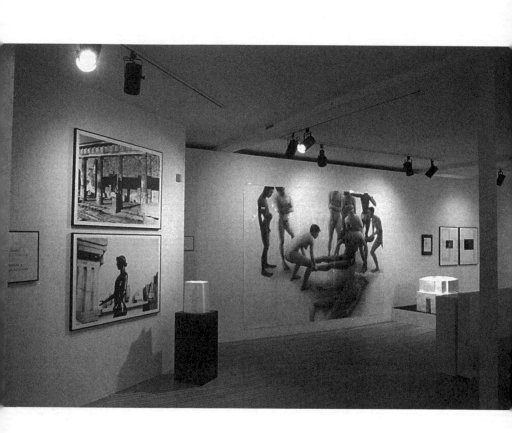

Gallery installation which shows the juxtaposition of my work
(on the left) with that of Hamish Buchanan (on the right).

Poems from *A Formal Affair*

Portugal, Italy, England, 1986–1989

Exploring the gardens of Portugal in the late 1980s, I experienced an underlying darkness not apparent at first glance. Beyond the riotous blaze of Bougainvillea and azulejos in the 17th- and 18th-century noble gardens were traces of the scars of earlier times.

Near Alcácer do Sol is a sixth-century B.C. Phoenician hillfort. It was rebuilt by the Romans, followed by the Moors, and finally conquered by Alfonso II in 1217. I photographed the tessellated floor of the Crusaders' Chapel bloodied by the wounds of time.

At Gardone Riviera on Lake Garda in Italy I stumbled into Il Vittoriale. The pink stucco palace was built by Mussolini as a gilded jail for Gabriele d'Annunzio (1863–1938). D'Annunzio thought he could prevent war by bombing Germany with poetry. His tomb rises starkly skyward against a shield of Lombardy poplars.

The eruption of Vesuvius in A.D. 79 buried the Campanian city of Pompeii leaving it suspended in time. Archaeologists have gradually been able to uncover the structures of public buildings, houses, and gardens. The mathematical simplicity of the Forum Romanum stands in contrast to the intimate remains of private gardens.

At Bowood Gardens in Wiltshire, England, the upper terrace was laid out with flat-topped clipped yews. The Italianate nature of this part of the garden is emphasized by the campanile rising above the façade of the house.

In 1986 I was invited to execute a collaborative exhibition at Gallery 101 in Ottawa, with a younger artist, Hamish Buchanan. He had been assisting me in my studio for several years in the realization of my fetish boxes (e.g. *The Sorceress*). Hamish was working on a large mural-sized drawing of ten nudes (see page 54). In his drawing there was a resonance between my photographs and the statue-like formality of his figures. There was also a connection between his sculptures and the formal quality of the spaces I had photographed. My poems were an integral part of the exhibition.

▨

Barn

Shelter from wild beasts, monsters of darkness and

the dead hand of winter.

Muffled pounding of feet on stone.

Dirge for the dead:

27 priests and a fat, swollen bishop follow the coffin

waving dried palm fronds, chanting, chanting.

The wolf howls at the locked gates to the village.

Across the worn tiles the wind swirls

bone dust of crusaders

who raped and pillaged in the name of Christ.

Aljubarrota, Portugal, 1986

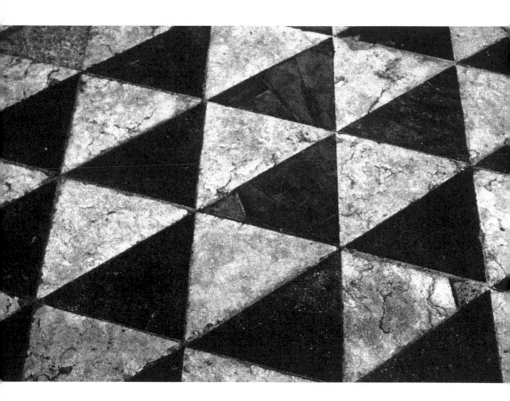

Tomb

Ceremonial container for dust and ashes:

the blood of warriors,

the wings of the poet.

Il Vittoriale, Italy, 1986

❈

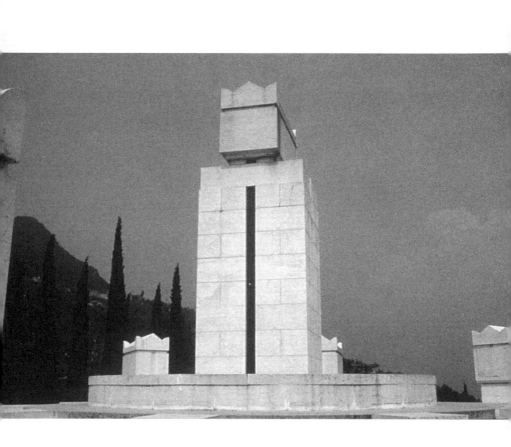

Arch

Two acrobats embrace on the highwire:

the final ecstasy

before Armageddon.

They found lovers in the ashes of Pompeii.

Pompeii, September 1988

❈

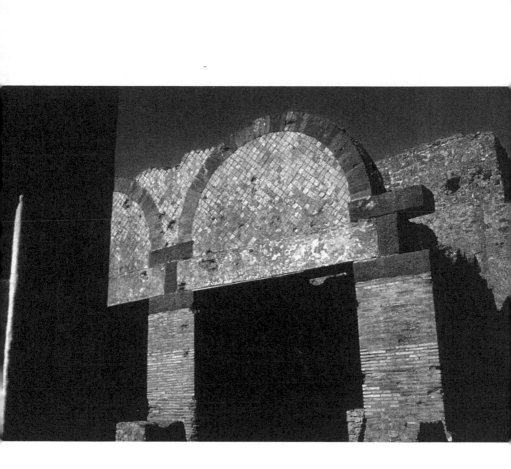

Watchtower

Guelph or Ghibelline: friend or foe,

lover or ravisher?

Abandoned sentinel:

reliquary for the famished heart.

Bowood, England, 1988

❈

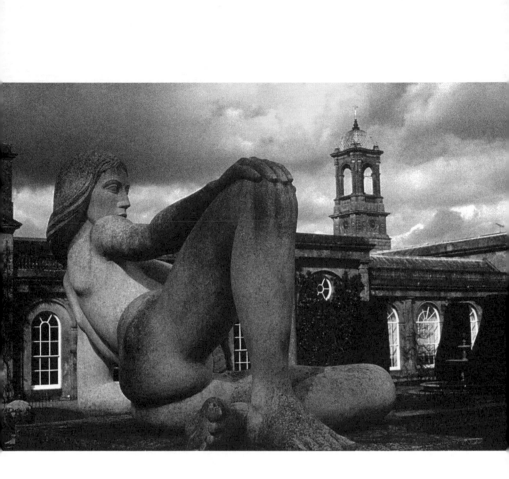

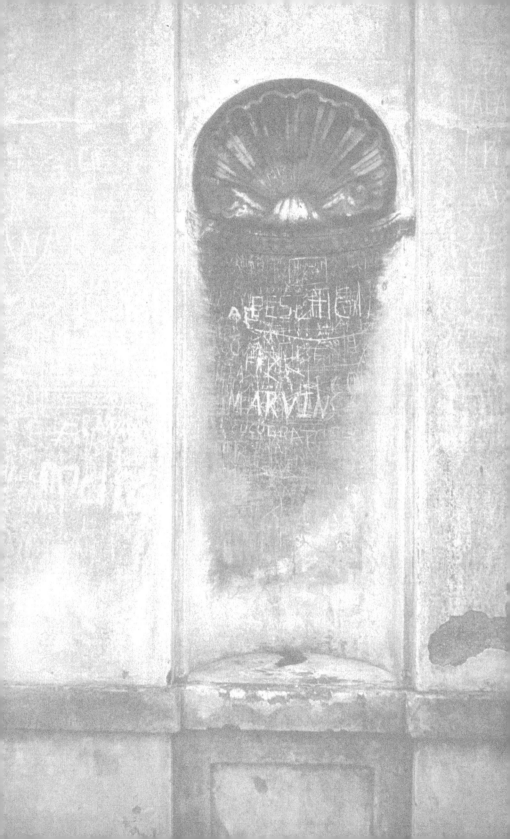

Poems from *The Last Silence*

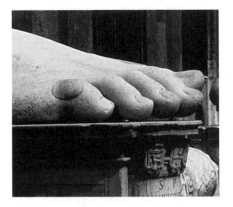

Italy, 1991

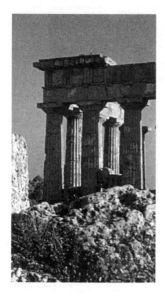

Between 1980 and 1990 I made a series of personal journeys from the South to the North in Italy. I was following my instincts and my intuition. Multiple visits were necessary in order to align myself with the depth of history.

I became obsessed with the echoes which survived the lives of certain historic figures. Among these was the Emperor Hadrian. Two noble women preoccupied me: Isabella d'Este and the Borromeo Princess. I photographed in black and white for documentary purposes and in colour for interpretive means.

With the support of the Italian Embassy in Ottawa, I gained access to places not normally open to the public. When *The Last Silence* opened in Italy it was in the Palazzo Te in Mantua. I was able to bring Isabella d'Este back to life in her own city.

In the fragmented statues of the Capitoline Museum in Rome I allude to the tragic love story of Hadrian and Antinous. (I subsequently followed the trajectory of their relationship in Turkey.)

The Last Silence: Pavane for a Dying World was curated by Martha Langford, Director of the Canadian Museum of Contemporary Photography, now integrated into the National Gallery of Canada.

Place of Stone

Silence.
Cicadas shrill in dried grasses
and the wind rasps.
Here once gentle Juno lay,
her sacred goats nibbling
on fallen figs.

Seven temples to face the rising sun:
Temple G to Apollo (or was it for Zeus?)
E to Juno, A to Castor or Pollux.
Houses of idols: They were all the same
to Hannibal.
He smashed the lot in 409 B.C.

Then came the Romans. Finding gentle goatherds
amongst the ruins, these
they enslaved.
Freed by Saint Paul, martyred by Diocletian,
their bones meld with the stone
of desecrated temples.

Noon sun on high, a ritual for Juno
goddess of childbirth:

Three steps up the stylobate:
Place of Stone, drinking blood. And in the sanctuary
a cacophony of crows.

❈

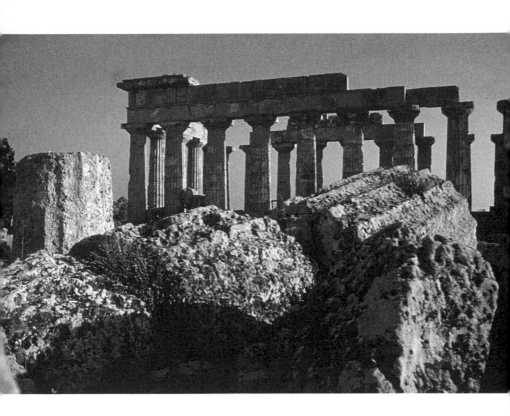

To Dionysus

Where once sweet winds of reason blew

the race was for the sons of man,

not gods; now lizards sun.

The echoes of the triumph fade

into mosaics in the tepidarium.

And all that's left of emperors—a hand,

a foot for pillaging.

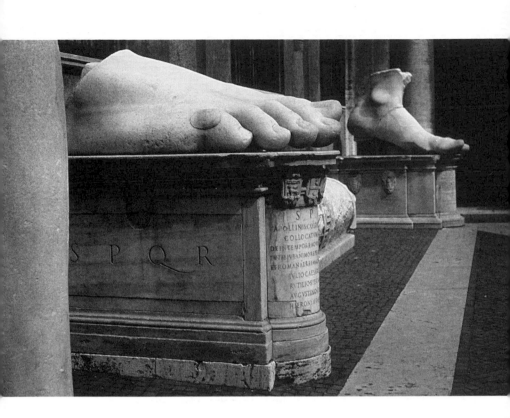

For how could savages be moved

by looking on forbidden joys,

O young Dionysus?

Now beauty pines alone, and in these sunlit halls

the wounds of love

are suppurating stone.

The Capitoline Museum, Rome, September 1989

❁

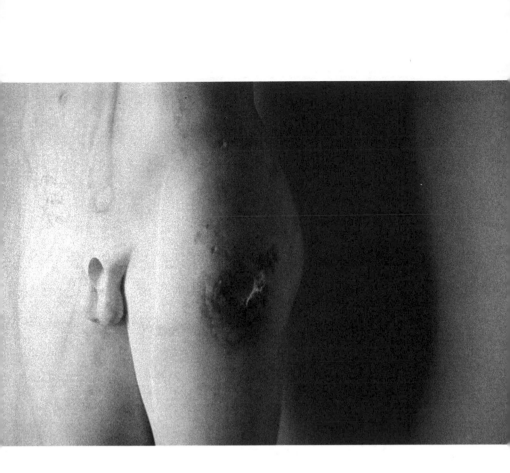

Dovecote

The Cardinal created a garden on the Palatine Hill:

Orti Farnesiani.

At noon she releases the doves.

Up into the blinding light they soar

to copulate with gods.

The Cardinal created a garden on the Palatine Hill:

Rome glittered at his feet.

His pages laughed, and stoned the doves.

In the loggia of the abandoned garden

the ragazzi scratch obscenities,

and piss in homage to the House of Farnese.

Rome, September 1988

✾

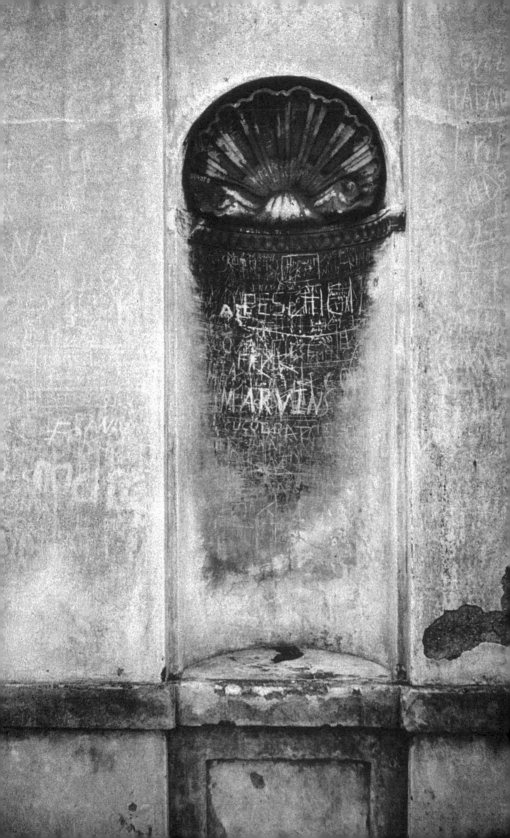

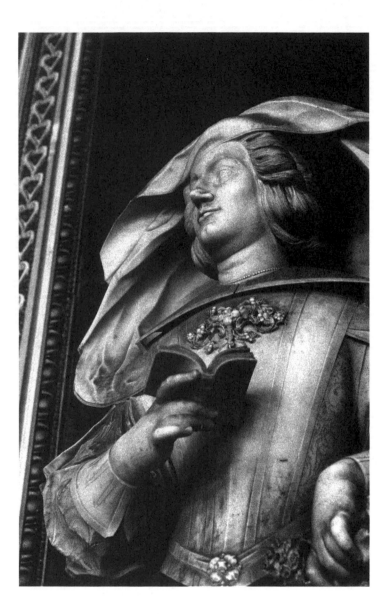

The Secret Garden of Isabella d'Este

Mantua, 1989

Isabella d'Este

Isabella d'Este's life as the First Lady of the Italian Renaissance is well documented. Less has been written about her personal life.

She was born in Ferrara in 1474, the first-born of Ercole I, Duke of Ferrara. Her father ensured that she obtained an unusually broad education for a female of her generation. She was highly articulate, and her intelligence was noted early. Her appreciation of literature, Latin, music, and painting was parentally encouraged. This aptitude blossomed as she became, in adulthood, one of the leading collector-patrons of her age.

Betrothed at the age of six to Gianfrancesco Gonzaga of Mantua, she was married at sixteen. She bore Gianfrancesco two daughters and two sons.

Gianfrancesco was a professional soldier, selling his services to whichever faction appeared most likely to be politically dominant, be it the Republic of Venice, the Pope, or the King of France. Isabella's talents as an administrator, diplomat, and political tightrope walker grew rapidly during the frequent absences of her husband. She was honoured by Popes and her counsel valued by kings; her wisdom steered the small state of Mantua through a tumultuous age. The stability and prosperity of Mantua, which avoided both foreign invasion and plunder, were largely a result of Isabella's political acumen.

In contrast to the glory of her political and economic achievements, her personal life was one of sorrow and disillusionment. Despite the fact that hers was an arranged marriage, she was deeply in love with Gianfrancesco. She found his promiscuity difficult to bear. Most wounding of all was his passionate liaison with Pope Alexander's bastard daughter, the beautiful Lucrezia Borgia. The spider's web of relationships was rendered more complex by the arranged marriage of Lucrezia Borgia to Isabella's brother, Alfonso d'Este, Duke of Ferrara.

In Isabella d'Este's later years her emotional focus became her son Federico Gonzaga, as Gianfrancesco succumbed to the final devastation of syphilis, dying in 1519.

Isabella d'Este retreated to the seclusion of a series of small chambers around the Giardino Segreto in the rambling ducal palace in Mantua. It was in one of these rooms, overlooking the garden, that she died in 1539. She was sixty-five years old.

This sequence of photographs, taken in these private spaces in June 1989, is an attempt to reconstruct her private state of mind.

▨

Spider

I governed the state

for the tranquility of your mind,

my Lord.

❈

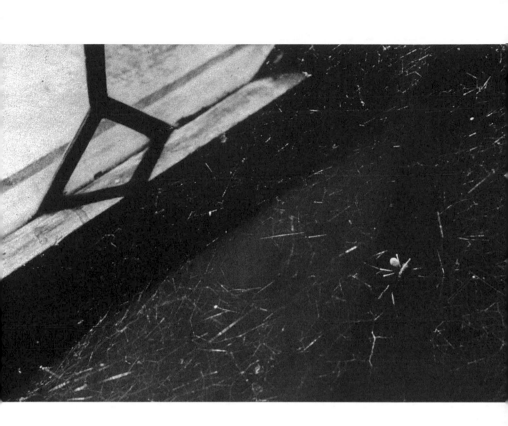

Window

Octagonal crystal:

the translucent wall between Your Excellency

and me.

❈

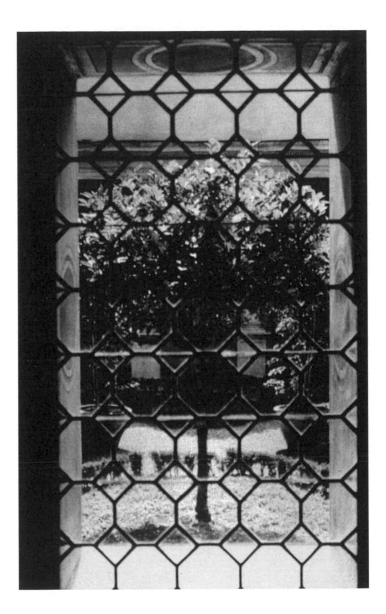

Giardino Segreto

A labyrinth to contain my restless soul.

❈

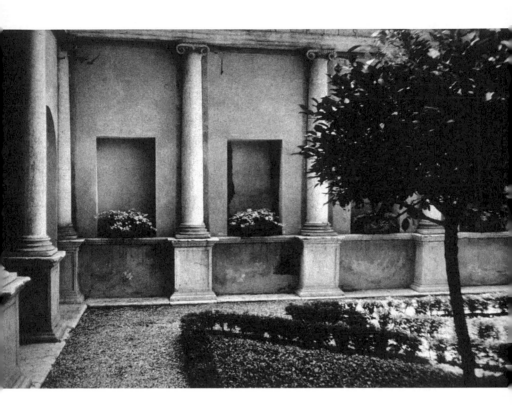

Blind Window

The fresco of reality denies the dream.

❄

Niche

Bereft of idols, my heart defaced:

your final betrayal with the Pope's bastard.

❁

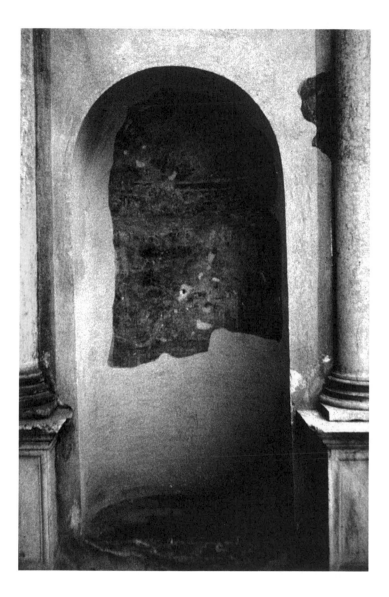

Bones

I do not know if I am alive or dead.

Your Excellency has loved me little

for some time past.

❈

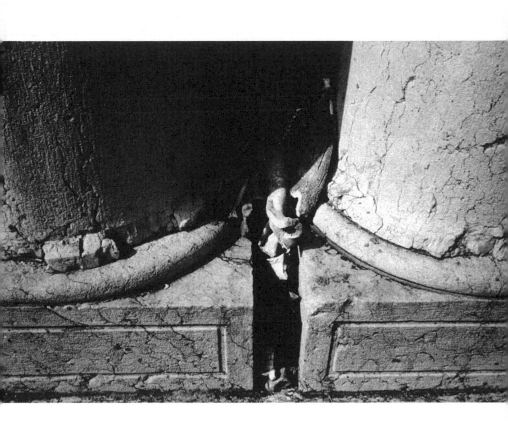

Paraphrased from the letters

of Isabella d'Este, Marchesa of Mantua,

to her husband, Gianfrancesco Gonzaga.

Mantua, 1506 and 1989

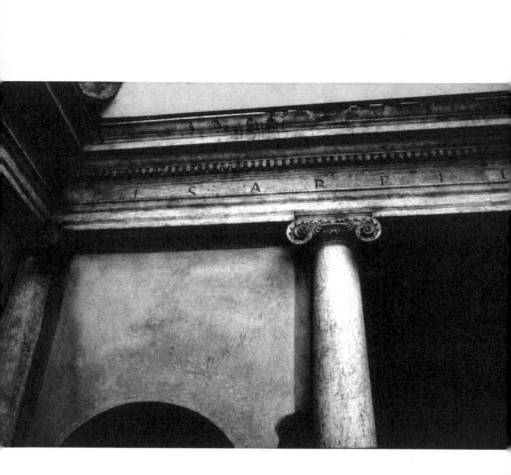

The Gardens of Isola Bella

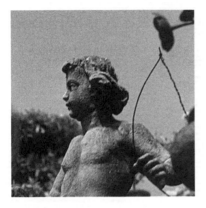

1630–1989

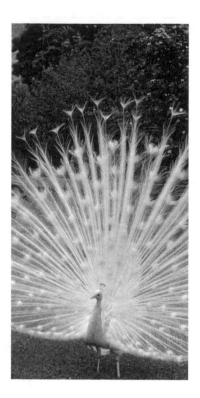

Isola Bella is one of three small islands on Lake Maggiore, in the north of Italy west of Milan. Sparsely populated by fishermen until the early part of the 17th century, the rocky outcrop eventually came to attract the attention of the Borromeos, an influential family of Milanese bankers who launched a grandiose project that would lead to the creation of the baroque palazzo and the terraced gardens.

The ongoing construction took shape under the patronage of Vitaliano VI Borromeo (1620–90) who engaged the architect Carlo Fontana to turn the villa into a venue for elaborate festivities and theatrical events for the nobility of Europe.

The island reached the pinnacle of its social dominance under the stewardship of Giberto V Borromeo (1751–1837) when guests included Napoleon and his wife, Joséphine de Beauharnais; Edward Gibbon, author of *The Decline and Fall of the Roman Empire*; and Caroline of Brunswick, the Princess of Wales. It is said that Caroline, once smitten with the place, did her best to convince the Borromeo family to sell her the neighbouring Isola Madre or the Castelli di Cannero but was forced to settle for a more modest estate on Lake Como at Cernobbio.

It is also said that the Canadian artist Tony Urquhart once took his betrothed to Isola Bella when they were courting.

The Rape of Cythera

Beloved Wife:

I will create for you a garden,

testament of my love.

In it the roses will always be in bloom.

The perfumed air will be fanned

by the outspread tails of peacocks.

Your laughter will alternate with sighs of delight.

Carlo Borromeo, 1630

❋

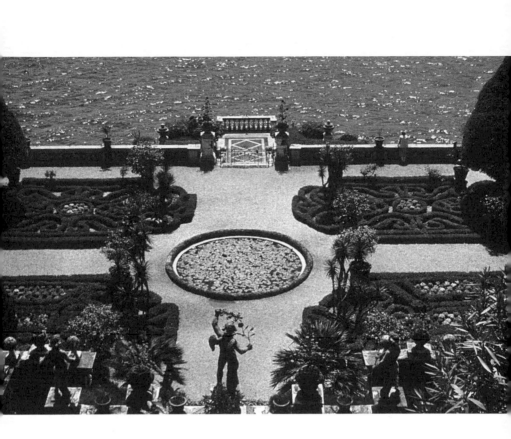

Beloved Husband:

I cannot find you in my garden.

I cannot see you for the throng of pilgrims

bearing votive offerings to the Unicorn.

The gardeners torment my peacocks

until they wail like banshees.

One million pilgrims, two million feet

pounding the roots of my camphor tree.

How can I bear the pain?

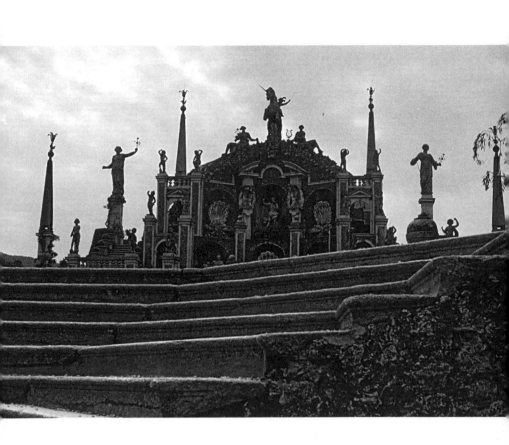

Beloved Husband:

If you love me, build me a garden.

Build for me a garden in a fortress,

a fortress which has no gate.

Isabella d'Adda dei Borromeo, 1989

❀

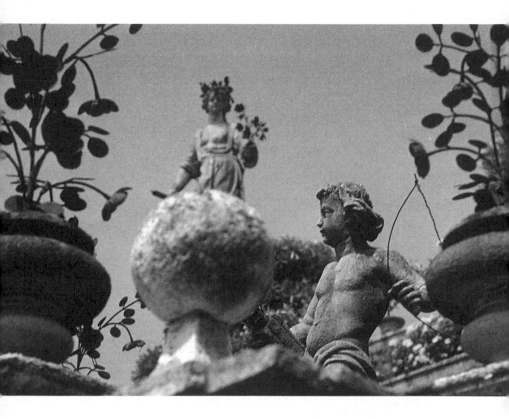

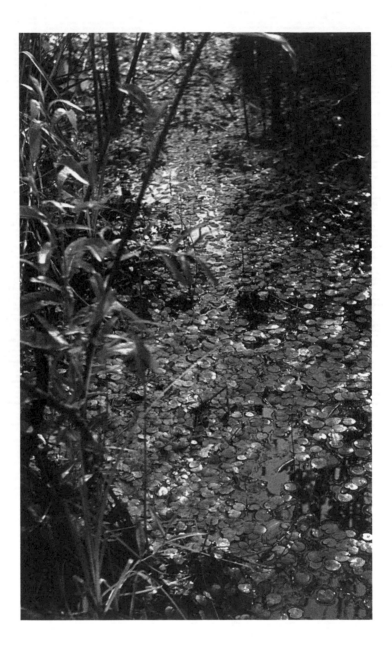

Lament

1954–2000

The Garden as Sanctuary

All that remains is love and memories.

On October 24, 2018, my husband died after a long ordeal with vascular dementia. I nursed him as he turned backwards in time into a charming six-year-old boy.

By February 2020 the world had collapsed due to COVID. Simultaneously, my final exhibition, *The Credo Project*, opened at the brand-new Ottawa Art Gallery. Artists and members of the cultural community were triumphant after over twenty years of fighting and lobbying for a home for Ottawa art. In 2021 I donated all the portfolios of my garden images to the Ottawa Art Gallery's permanent collection.

In December 2019 I flew to London to support the election of the first female President of the Royal Academy of Arts, Rebecca Salter. She was elected just in time to deal with the full impact of the COVID pandemic. This was my final visit to England. Now I immerse myself in the gardens of memory.

I look back on a life through gardens. It took me twenty-five years to finally see the fountains of Versailles in play. Memories of my mother's roses were stirred by the roses along the canal in the Generalife in Granada. My sister Jane (who often accompanied me) and I were deeply moved by the symbolism and structure of Derek Jarman's garden in Dungeness.

In a world which has gone completely insane it is those who cherish the Earthly Paradise who may survive.

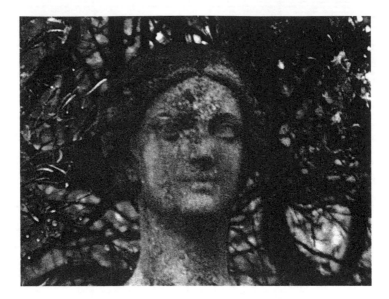

Lament

The King has joined the Panther

in death.

I am walking in a barren land, longing

to howl at the moon.

Words softly spoken, precisely

phrased.

Convoluted games and glances,

Ottoman ambiguities.

I am poised at the edge of the web,

holding my breath.

August 23, 2000

❈

So the wind blows: dark night, clear moon

bright day of ice.

Keep me between your fierce and shining eyes:

let not the sky devour me.

1980

❖

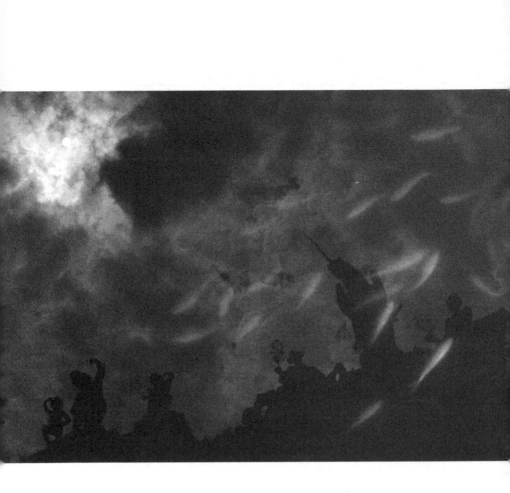

I have grown old and tired

waiting for you:

and now the leaves are falling.

1990

❈

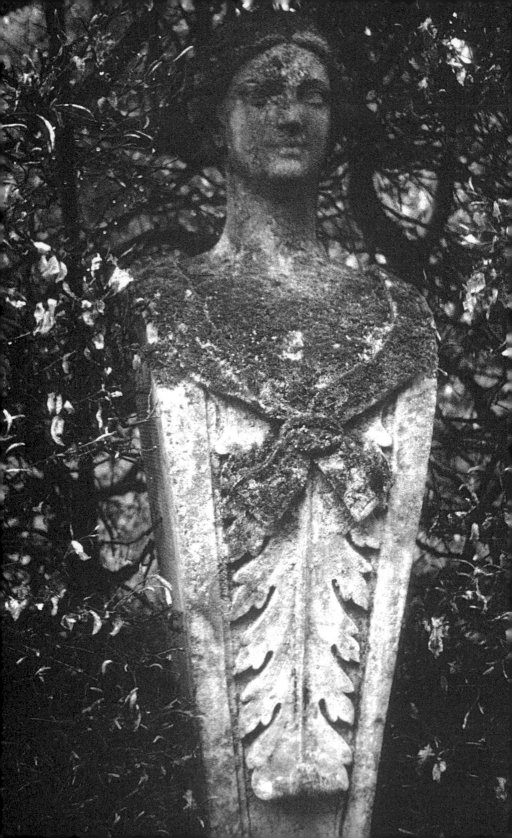

And if, in some quiet afterlife, you said:

Then come, Beloved, let us to the hills

and all the day lie sunning like soft spotted snakes

before they slough their skins away.

For laughter can shatter into pain,

and these small joys of this our private world will pass.

Eternity slips by, uncaught:

yet the eternal wind still sings through grass.

1954

❈

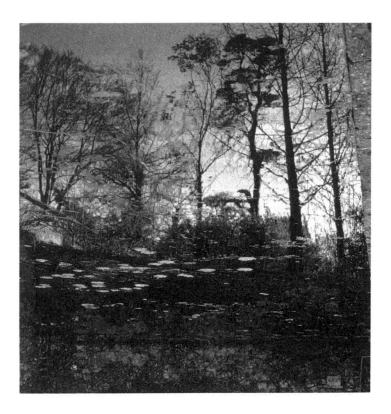

List of Images

Witchery, the Unicorn Amphitheatre, Isola Bella (cover)
Venus Callipygos, Stourhead (p. 2)

The Earthly Paradise, England, 1980–1982

The Cascade, Chatsworth (p. 13)
Roses for Marie Antoinette (p. 15)
Tempo Antica: II (p. 17)
The Sorceress (p. 19)

Out of Time, Jamaica, 1969–1970

Goats Bleat (p. 25)
The Eyes of This Dead Lady Speak to Me (p. 27)
Inward Voyage: II (p. 29)
Death Is Like Queensland: King (p. 31)

The Secret Garden, Canada, 1976–1977

Dream of the Captive (p. 34)
Passage of the Night-Hawk (p. 37)
The Secret Garden (p. 39)

The Hospital for Wounded Angels, Italy, 1980–1990

Venus and Adonis, by Canova (p. 40)
Venus Callipygos, Stourhead (p. 45)
Garden in Lucca (p. 47)
Flowers of the Labyrinth, Isola Bella (p. 49)
Margherita Dei Medici and the Little Princes, Isola Bella (p. 51)
Statue by Canova (p. 53)

Lament, 1954–2000

I would like to thank Tim and Elke Inkster for their visionary
support, and Robert Haan for his technical assistance.

—Jennifer Dickson

Credit: Dennis Toff FRPS, courtesy of
the Estate of the late Dennis Toff.

About the Artist

Jennifer Dickson had already established an international reputation as an artist before emigrating to Canada in 1969. Born in the Republic of South Africa in 1936, she studied at Goldsmiths College School of Art (University of London, England) and was an associate of the prestigious graphic workshop Atelier 17 in Paris.

Her early work—*The Secret Garden* (1976) and *Three Mirrors to Narcissus* (1979)—challenged assumptions about gender and sexual roles in Western society. During the 1980s and 1990s she travelled extensively in England, France, and Italy, focusing on the structure and symbolism of historic gardens. Beauty and its desecration became obsessions, culminating in *The Last Silence: Pavane for a Dying World* (1993–1997), part of the permanent collection of the National Gallery of Canada.

In 1976, Dickson was elected a Royal Academician (RA) by the Royal Academy of Arts, in London, England, the only Canadian in the two-hundred-year history of this prestigious institution to have been so honoured. She is, in addition, a Fellow of the Royal Society of Painter-Etchers and Engravers (London, England). She was named to the Order of Canada (CM) in 1995. She lives in Ottawa.

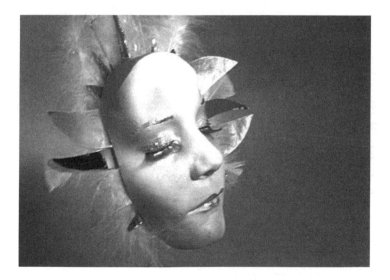

Moon Child (Portrait of Bill Sweetman, 1970).